In loving memory of my father, Dr. George Chiayou Yeh

—K. Y.

For my Gong Gong, who is also from a faraway place.

Even when he lived here, his mind never left his birth country

—H. V. L.

Text copyright © 2011 by Kat Yeh
Illustrations copyright © 2011 by Huy Voun Lee

First published in the United States of America in January 2011
by Walker Publishing Company, Inc., a division of Bloomsbury Publishing, Inc.
www.bloomsburykids.com

For information about permission to reproduce selections from this book, write to
Permissions, Walker BFYR, 175 Fifth Avenue, New York, New York 10010

Library of Congress Cataloging-in-Publication Data
Yeh, Kat.
The magic brush : a story of love, family, and Chinese characters / by Kat Yeh ;
illustrated by Huy Voun Lee. — 1st ed.
p. cm.
Summary: Jasmine's grandfather teaches her Chinese calligraphy by drawing and making up stories together.
Includes information about Chinese characters and a glossary of words in the story.
ISBN 978-0-8027-2178-5 (hardcover) • ISBN 978-0-8027-2179-2 (reinforced)
[1. Grandfathers—Fiction. 2. Chinese language—Writing—Fiction. 3. Storytelling—Fiction.
4. Chinese Americans—Fiction.] I. Lee, Huy Voun, ill. II. Title.
PZ7.Y3658Mag 2011 [E]—dc22 2010008443

Art created with cut-paper collage, Utrecht Easycut rubber stamps, and ink
Typeset in Brioso Pro
Book design by Nicole Gastonguay

Printed in China by C&C Offset Printing Co., Ltd., Shenzhen, Guangdong
(hardcover) 10 9 8 7 6 5 4 3 2 1
(reinforced) 10 9 8 7 6 5 4 3 2 1

The Magic Brush

A Story of Love, Family, and Chinese Characters

Kat Yeh

illustrated by **Huy Voun Lee**

WALKER & COMPANY
New York

Agong was Jasmine and Tai-Tai's grandfather from a faraway land. One spring, he came to live with their family.

He could fold rice paper into one hundred fluttering birds. He could peel an orange in one long curling, swirling peel. And he could name every tree and flower and insect in their garden.

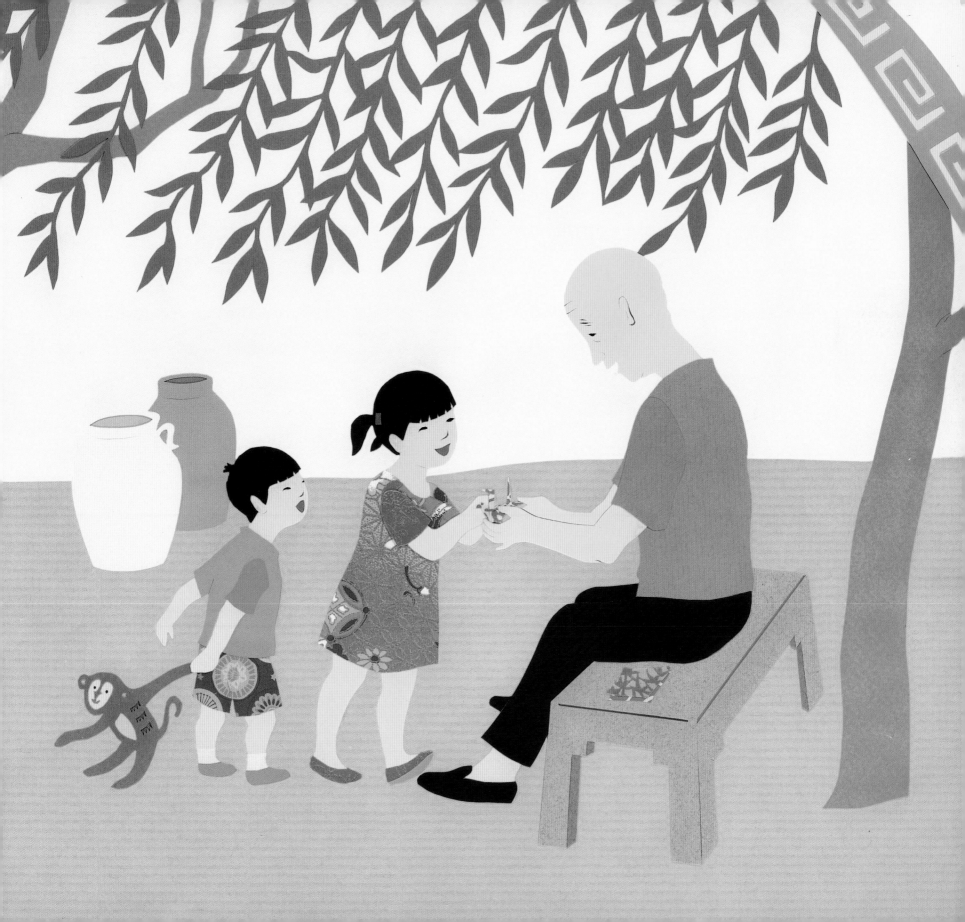

Jasmine was a big girl—too big to take afternoon naps anymore. Too big to feel sad in the empty playroom day after day while her little brother slept.

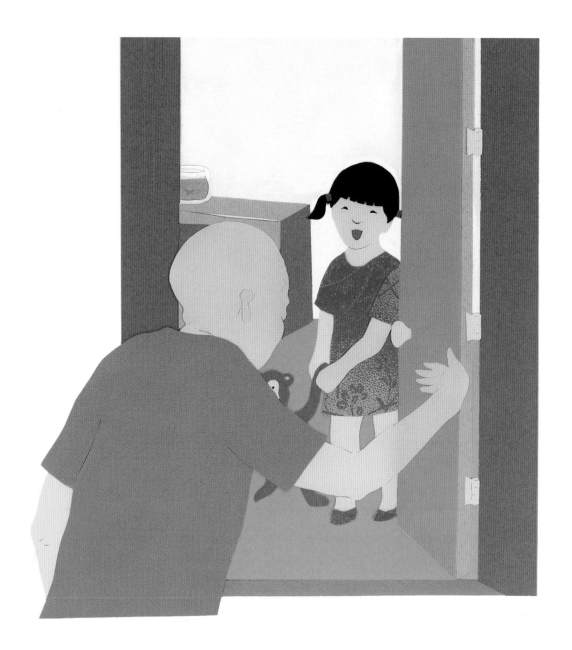

But one day, the playroom wasn't empty.

"Come with me, Jasmine," Agong said. "I think you are ready."

"For what?" she asked.

Agong smiled. "Magic."

Wide-eyed, Jasmine followed him to his room.

"First," Agong said, "you must make a wish. . . ."

Jasmine paused, then whispered shyly in his ear. Agong nodded. He poured a little clear water into the inkstone, mixing until it was the deep color of night. Then he put his hand over Jasmine's, and together they dipped the brush and touched it to the paper. . . .

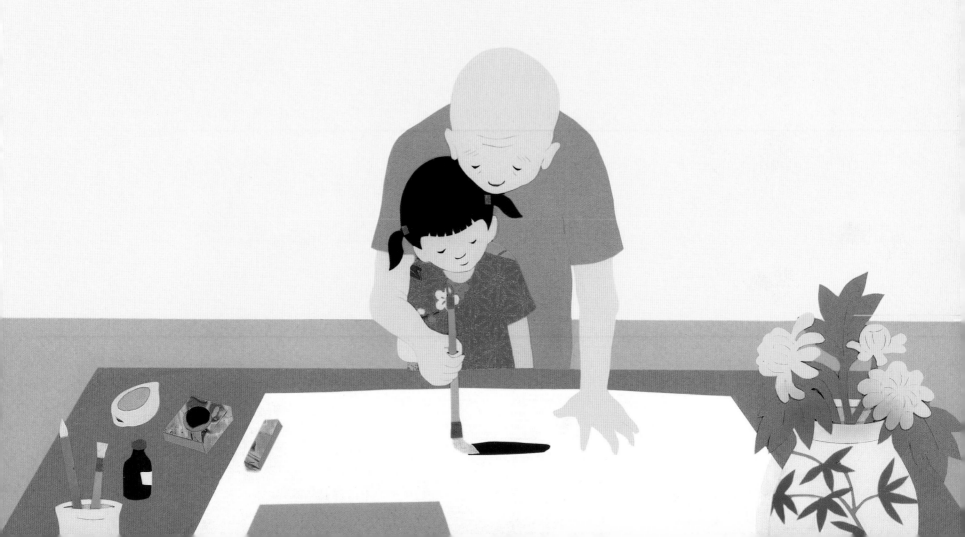

"Once there was a girl named Jasmine who could fly as high as the **moon** and the **stars**," Agong said.

月
moon

星
stars

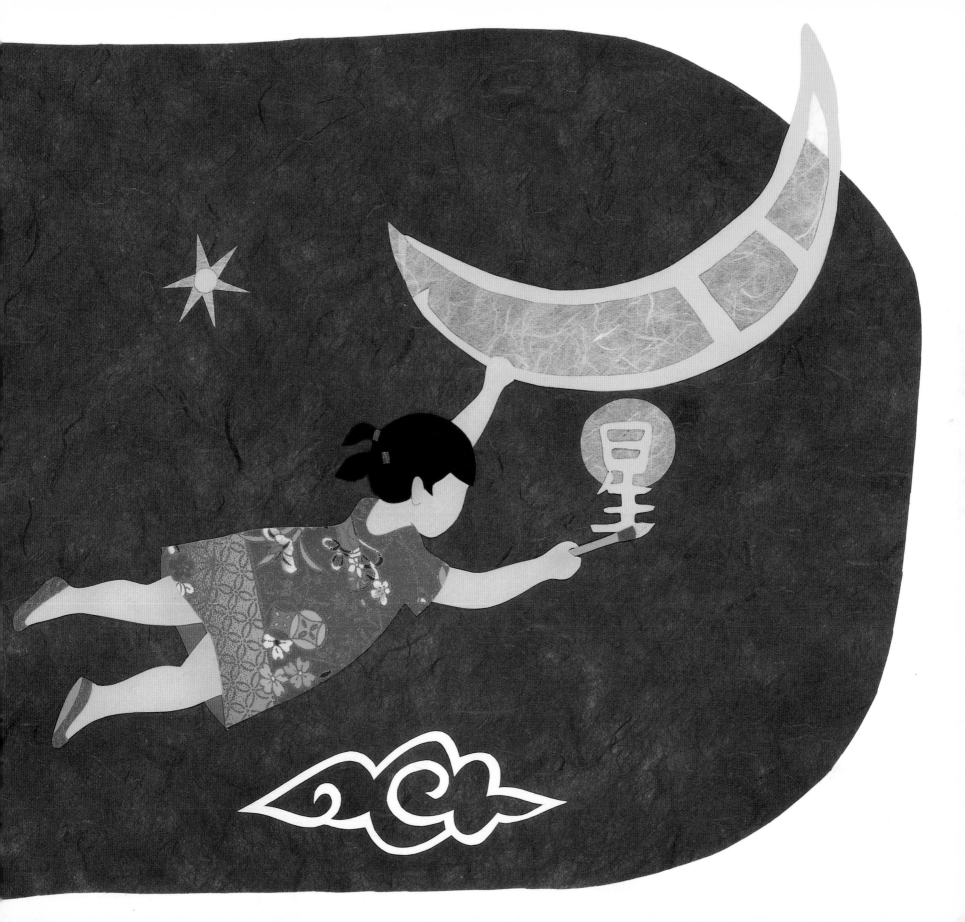

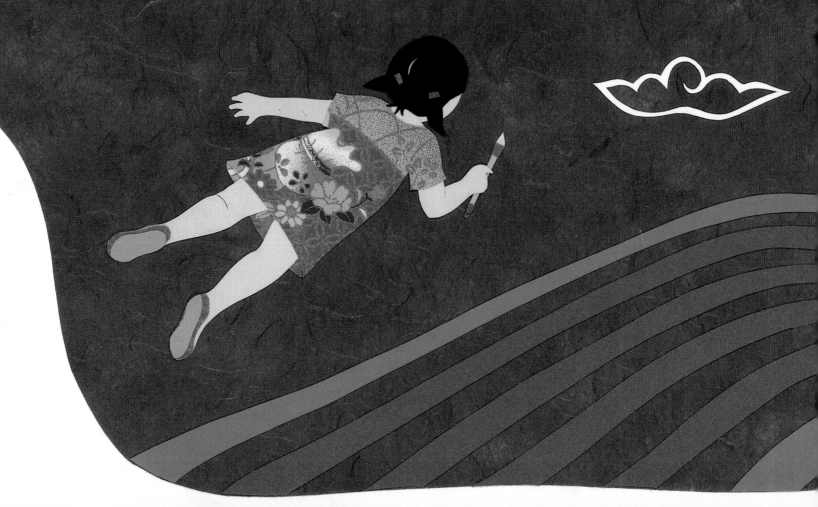

"And where shall she go, this flying Jasmine?" he asked.

"To rescue a baby dragon that lives at the top of the highest **mountain**, past a dark **forest** and a terrible rolling **river**!"

山
mountain

林
forest

川
river

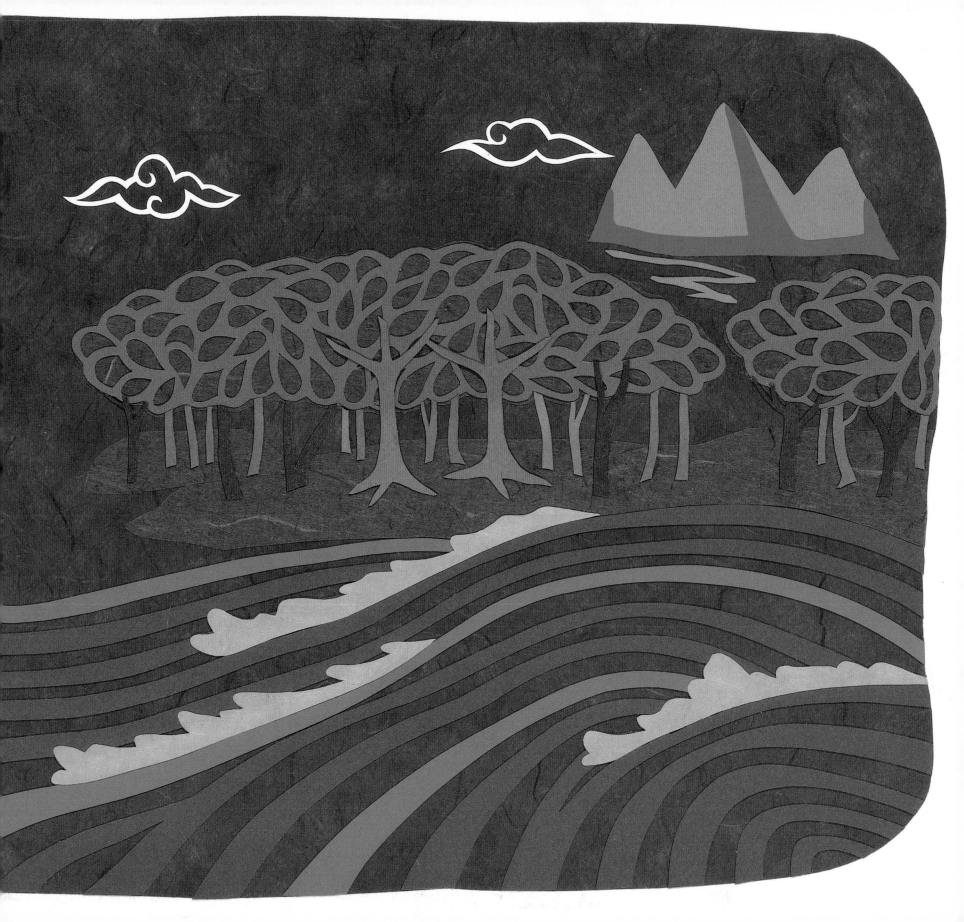

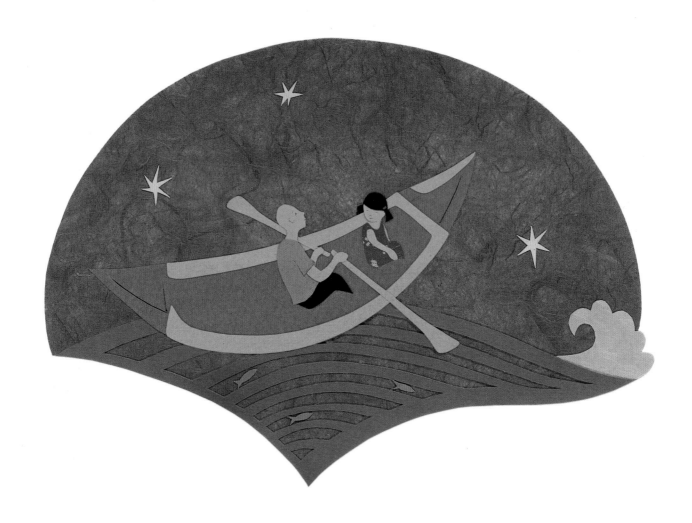

"And what of this river? Shall we wish for a **boat** to sail across?"

"Well, if you're not afraid of a little **water**, Agong, I think I'd rather wish for . . . a **fish**!"

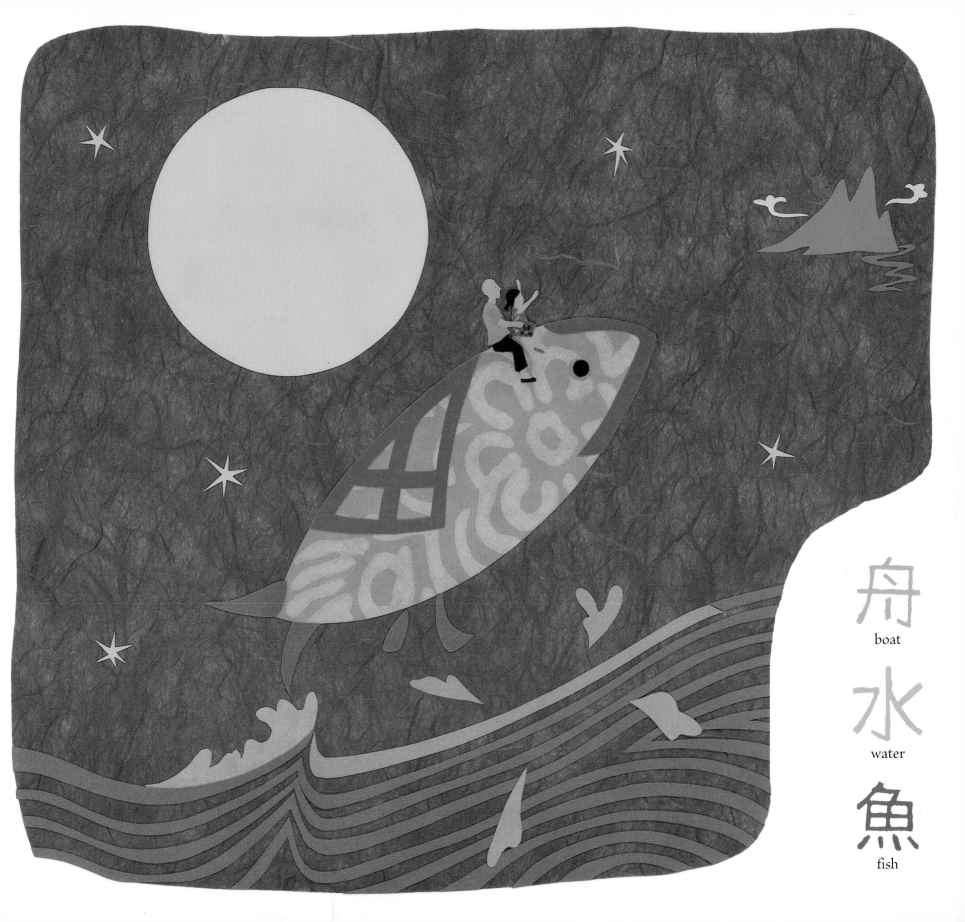

舟
boat

水
water

魚
fish

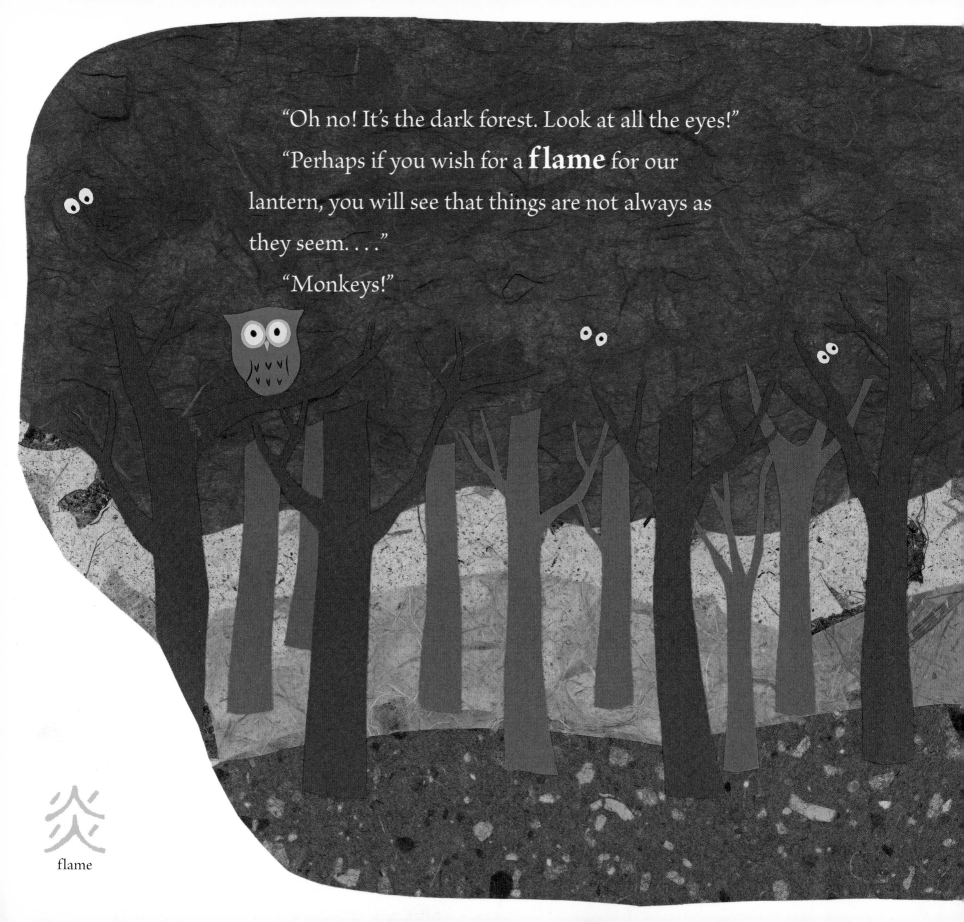

"Oh no! It's the dark forest. Look at all the eyes!"
"Perhaps if you wish for a **flame** for our
lantern, you will see that things are not always as
they seem. . . ."
"Monkeys!"

flame

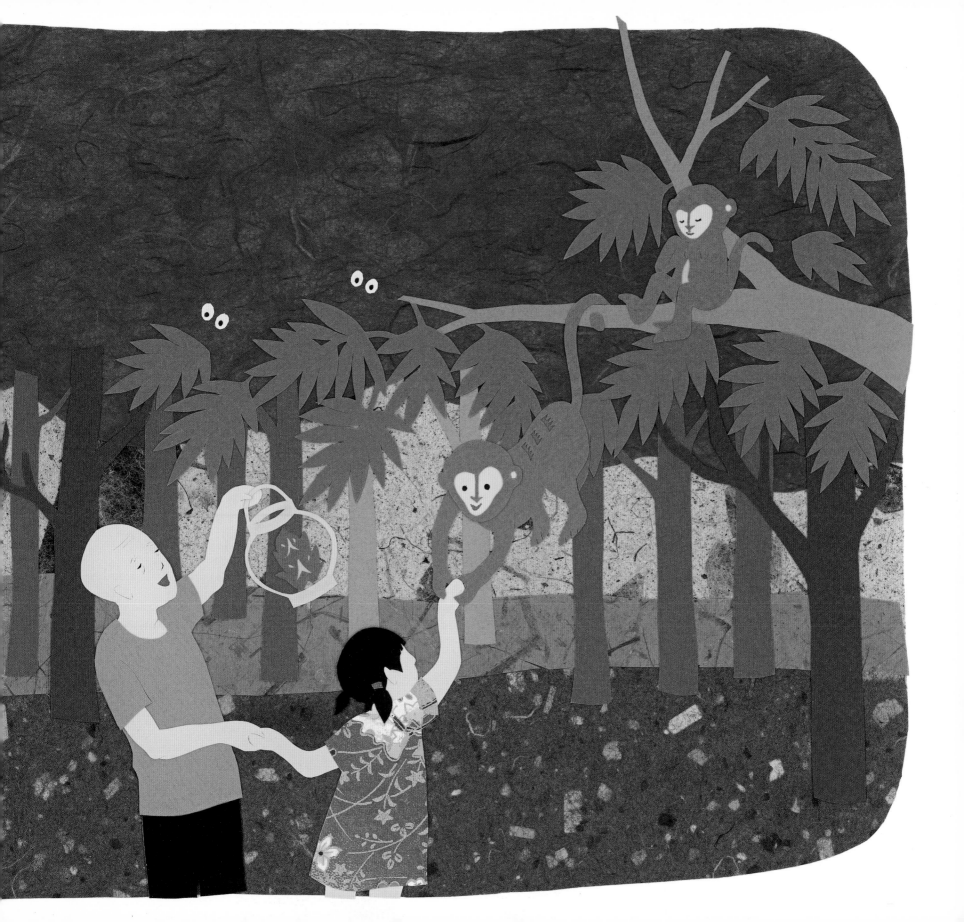

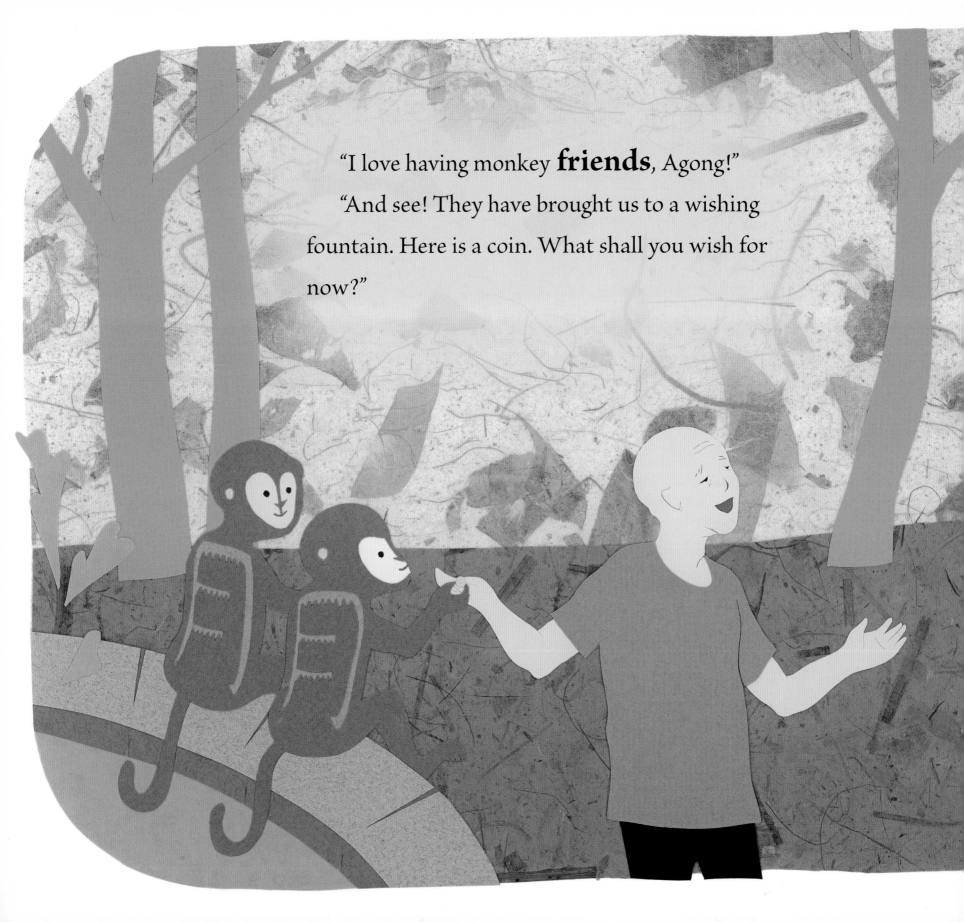

"I love having monkey **friends**, Agong!"

"And see! They have brought us to a wishing fountain. Here is a coin. What shall you wish for now?"

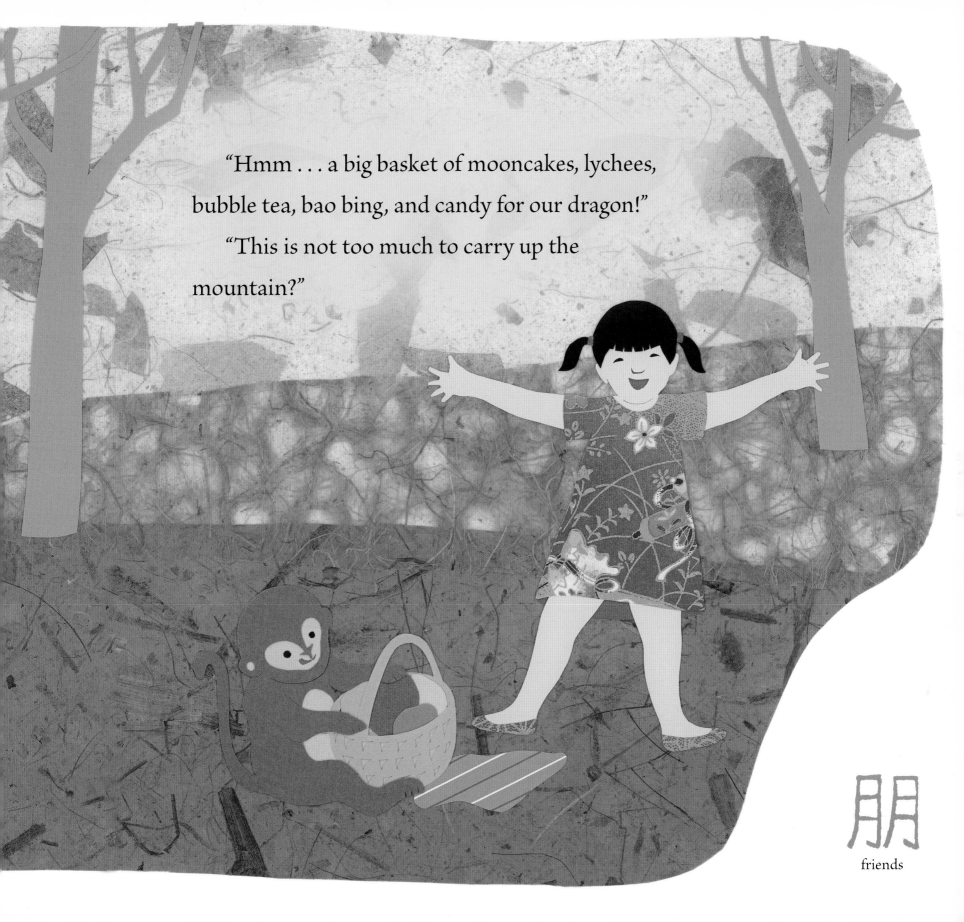

"Hmm . . . a big basket of mooncakes, lychees, bubble tea, bao bing, and candy for our dragon!"

"This is not too much to carry up the mountain?"

朋
friends

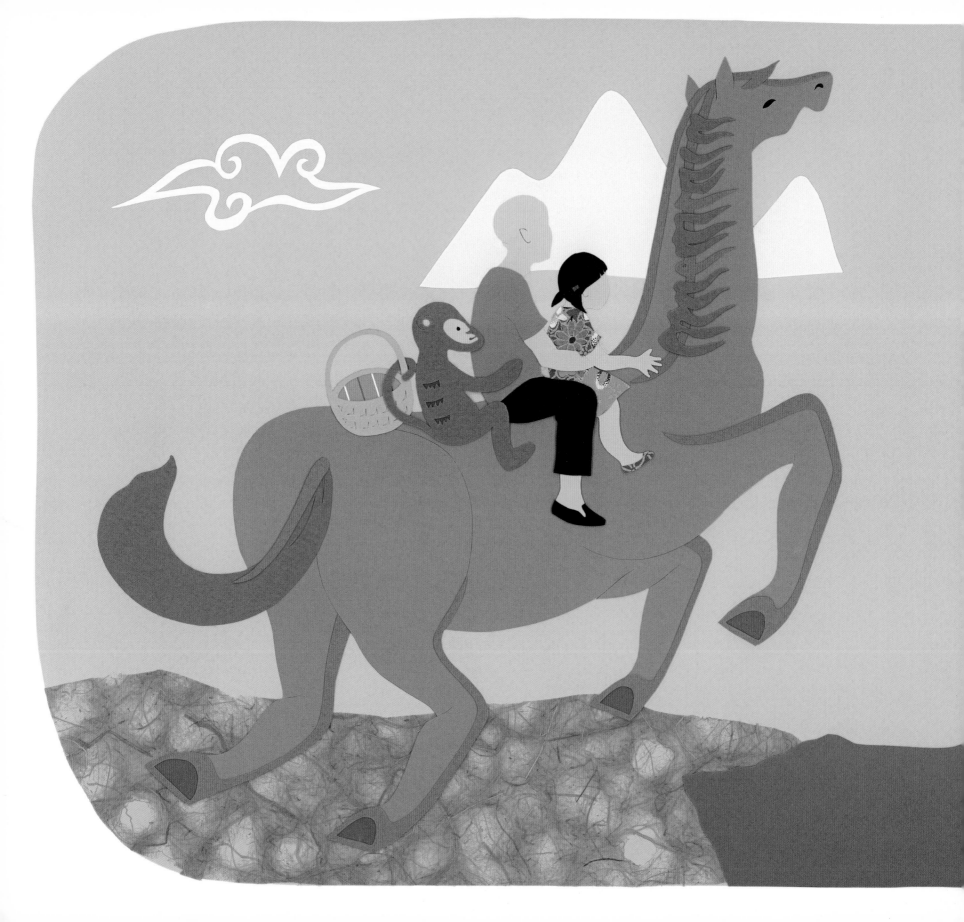

"Not if my last wish is for a **horse** that can fly!"

馬
horse

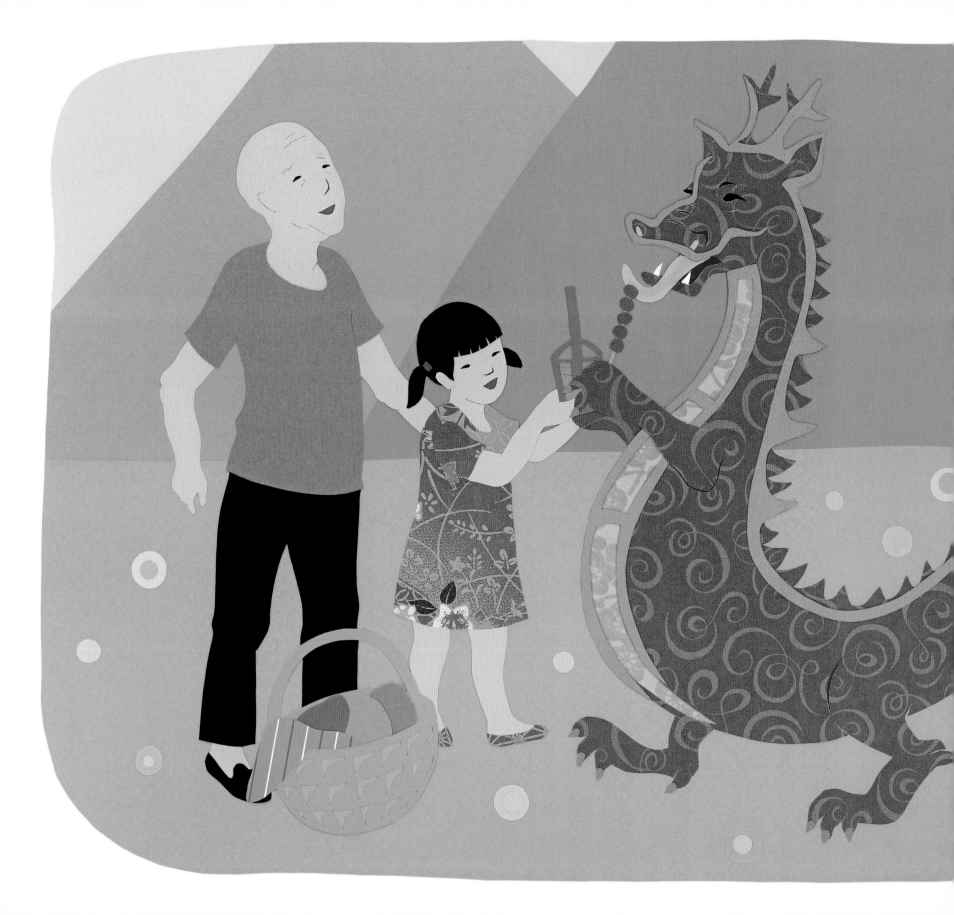

"Agong, I am going to feed my **dragon** and take care of her and— Can we come again tomorrow and every day?" Jasmine asked.

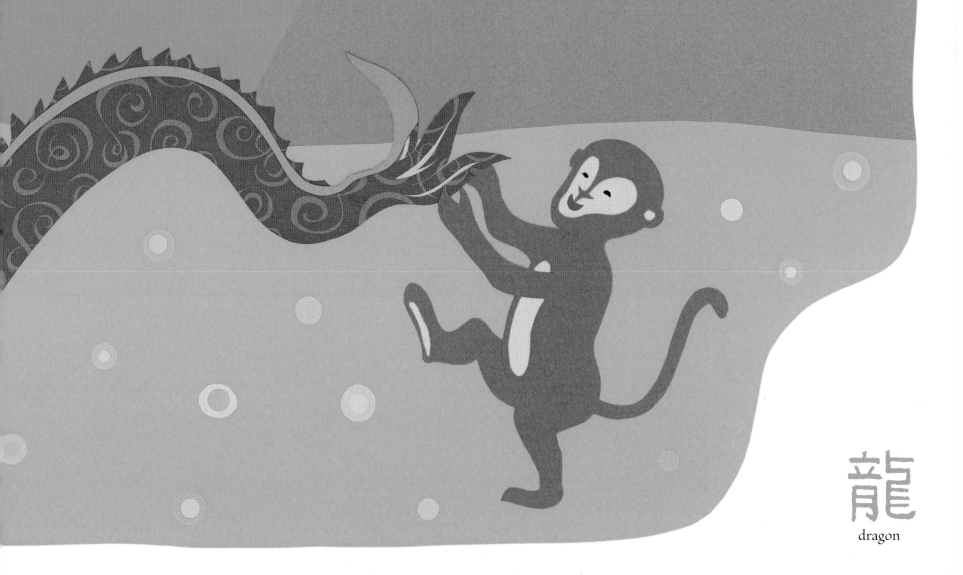

龍
dragon

Agong looked up from the papers.

"Yes, Jasmine, we can come every day. Shall we bring Tai-Tai too?"

"Oh . . . he still needs an afternoon nap. So just you and me. Okay?"

Agong smiled and bowed. Jasmine bowed back.

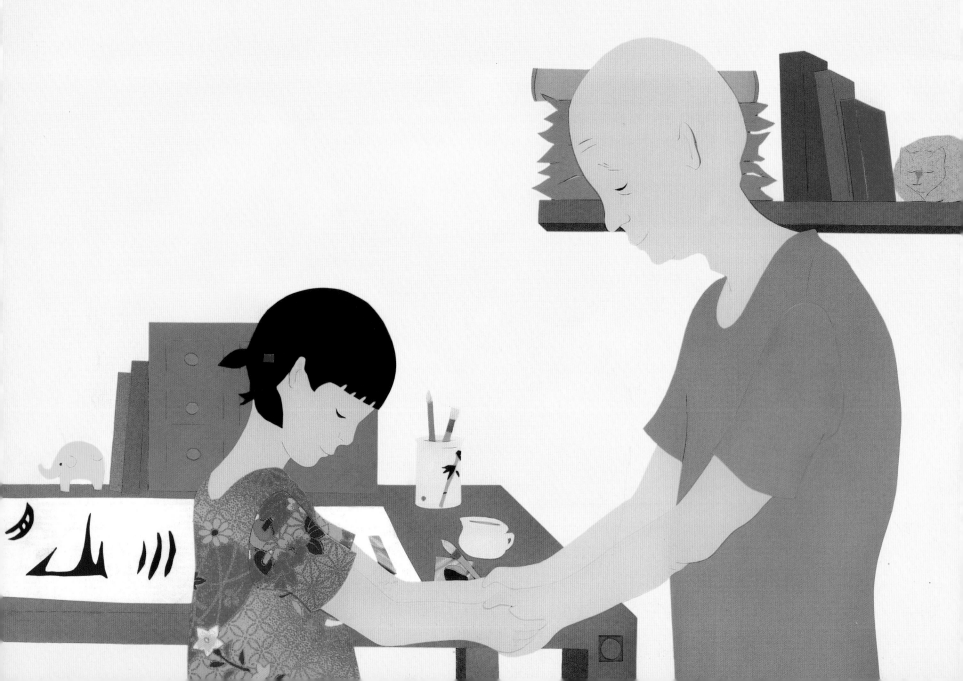

All that spring, they climbed mountains. All through the summer, they flew past the moon.

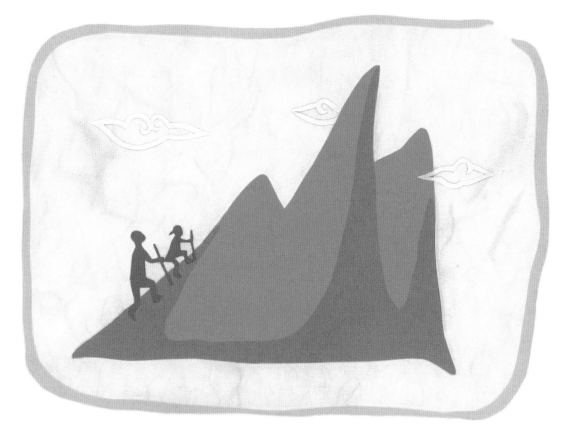

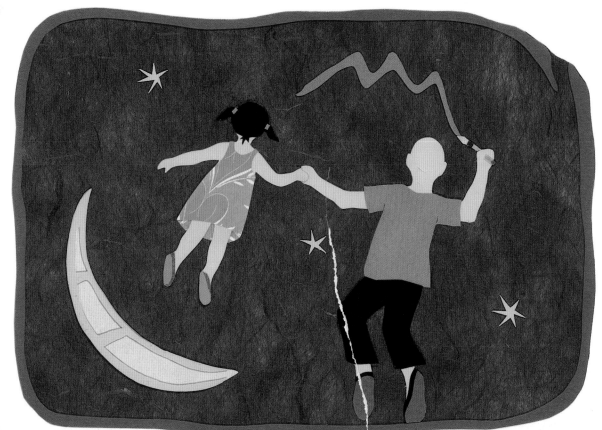

And Agong said that soon, Jasmine would have a brush of her own.

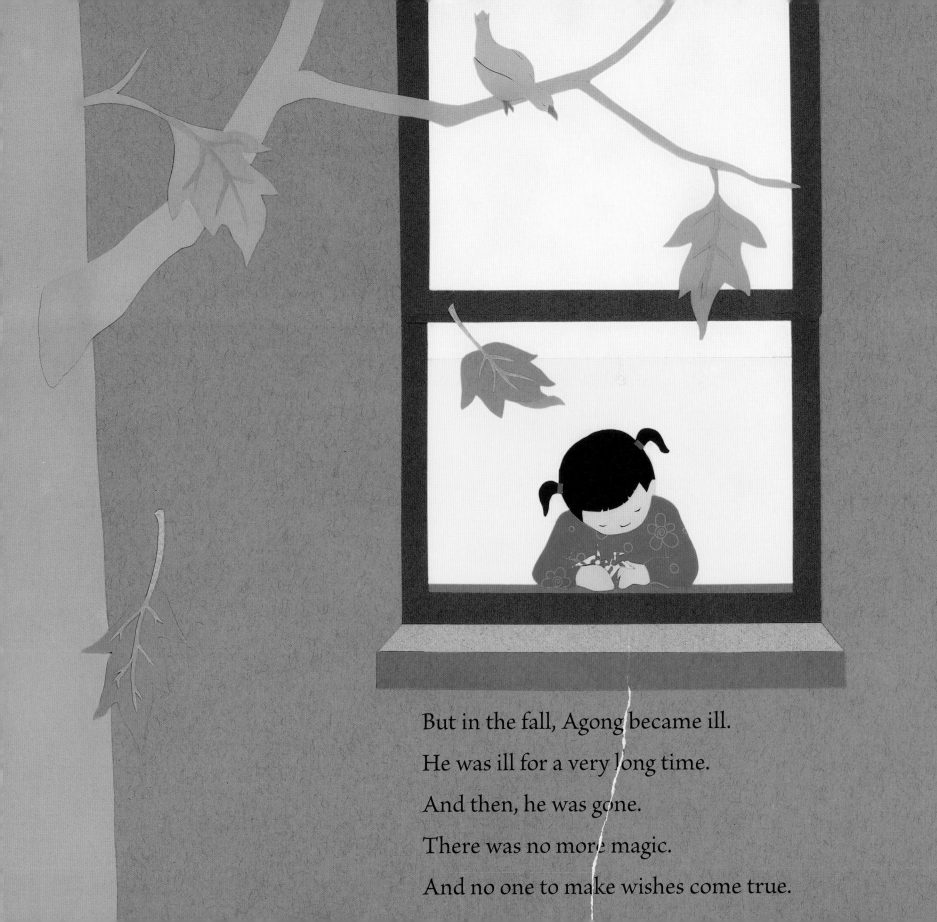

But in the fall, Agong became ill.

He was ill for a very long time.

And then, he was gone.

There was no more magic.

And no one to make wishes come true.

Jasmine was a big girl—too big to want her
afternoon naps again.

Too big to sit and wait alone day after day when
she knew Agong was never coming back.

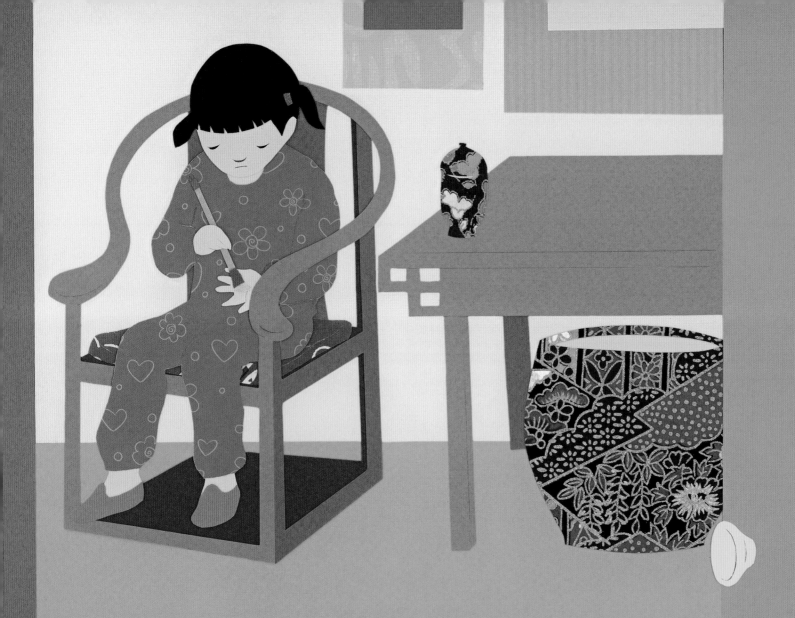

But one day, Jasmine wasn't alone. Tai-Tai had
snuck away from his nap to find her.

"Too big for nap!" he insisted. But he hesitated,
unsure, outside Agong's door.

Jasmine looked at her little brother for a long
time.

"Come here, Tai-Tai," she finally whispered.
"I think you are ready. . . ."

"For what?" he whispered back.

Jasmine smiled. A small, crooked smile. "Magic."

Wide-eyed, Tai-Tai came into Agong's room.

Jasmine poured a bit of clear water into the inkstone, mixing until it was the cool color of evening sky.

Then, taking a soft breath, she picked up Agong's brush. With her hand over Tai-Tai's little one, together they made a wish.

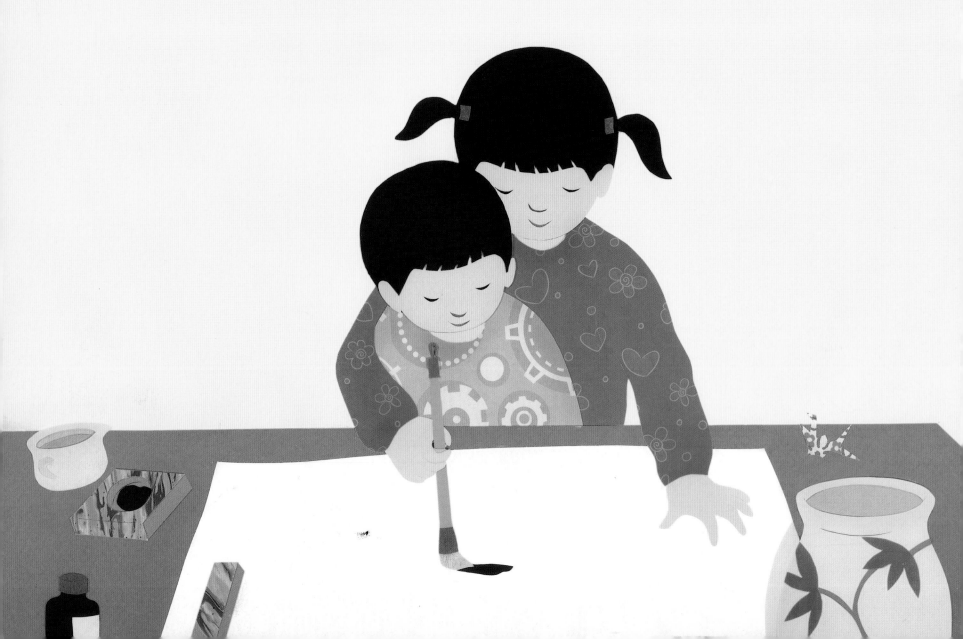

And it was just as their **grandfather** had said.

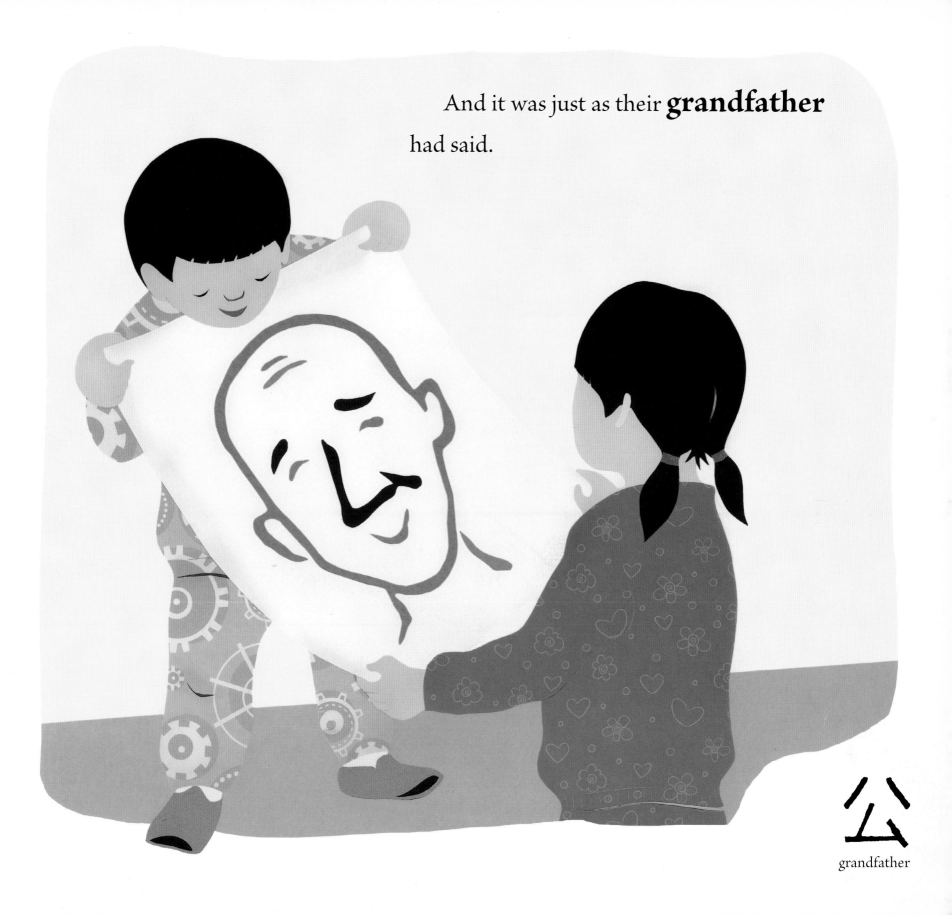

grandfather

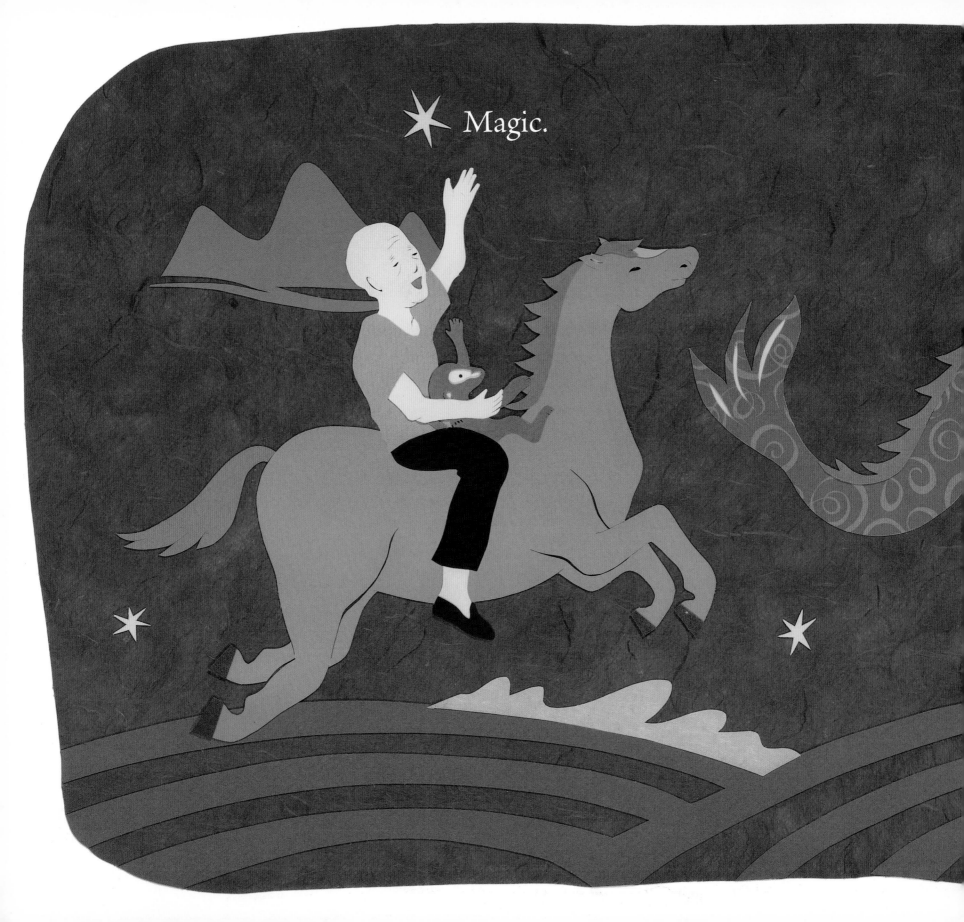

Magic.

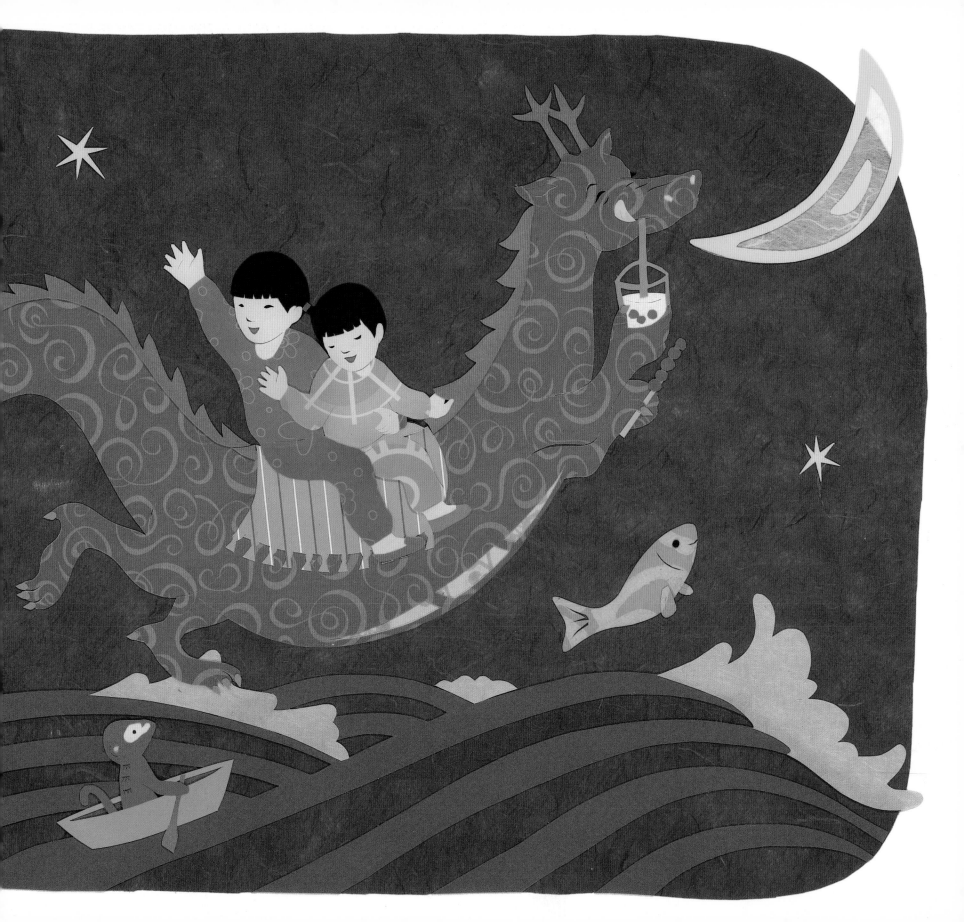

Pronunciation Key

It is important to pronounce Chinese words with the correct tone. If you use the wrong one, you could be saying a completely different word! There are four tones in Mandarin Chinese, which sound just like they look:

◆ The first tone (¯), as seen in "xīng" (stars), is pronounced with a high, level pitch that stays the same as you say it—like making a statement.

◆ The second tone (´), as seen in "yú" (fish), is pronounced with a high, rising pitch that gets higher as you say it—like asking a question.

◆ The third tone (ˇ), as seen in "mǎ" (horse), is pronounced with a low pitch that falls lower and then rises higher—like riding down and up on a roller coaster.

◆ The fourth tone (`), as seen in "yuè" (moon), is pronounced with a high falling pitch that gets lower as you say it—like sledding down a hill.

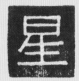
moon: yuè
(yeh)

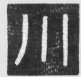
stars: xīng
(shing)

mountain: shān
(shan)

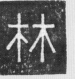
forest: lín
(lin)

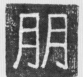
river: chuān
(chwon)

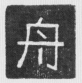
boat: zhōu
(jo)

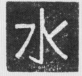
water: shuǐ
(sway)

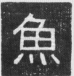
fish: yú
(yee)

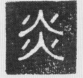
flame: yán
(yen)

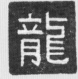
friends: péng
(peng)

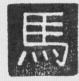
horse: mǎ
(mah)

dragon: lóng
(long)

grandfather: agōng
(a-gong)

History of Chinese Art

The artwork for this book was created with cut-paper collages, which is very fitting because paper was first created in China during the Han dynasty. Chinese paper-cut artwork, or *jian zhi*, is a folk art that is passed down from one generation to another and is a large part of Chinese life today.

When paper cutouts portray Chinese characters, they are often a symbolic representation of the words, showing the inspiration from where the character design came. This is another reason why *jian zhi* is fitting for a book illustrating the basics of Chinese characters.

Traditional Chinese paintings are also usually accompanied by a poem and a small handcrafted red stamp, called a name chop, bearing the artist's name.

Chinese Treats

Mooncakes: pastries filled with sweet lotus paste and egg with a pretty moon pattern on top. These are made for the Mid-Autumn Festival.

Lychees: delicious fruit that grows on trees. When you pick them, they are covered with a strange, bumpy pink shell. Inside, they look and taste a little bit like grapes.

Bao bing: beautiful shaved ice with fruit and flavored syrup. It is the Chinese version of an ice-cream sundae.

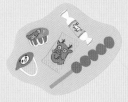

Candy: Chinese candy is colorful, fun, and often packaged with cute characters. Pictured are some favorites.

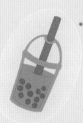

Bubble tea: cold Chinese tea in different flavors with fat tapioca pearls bobbing inside. It's fun to sip, then chew, then sip again.